THE ORDER OF THINGS
A BESTIARY

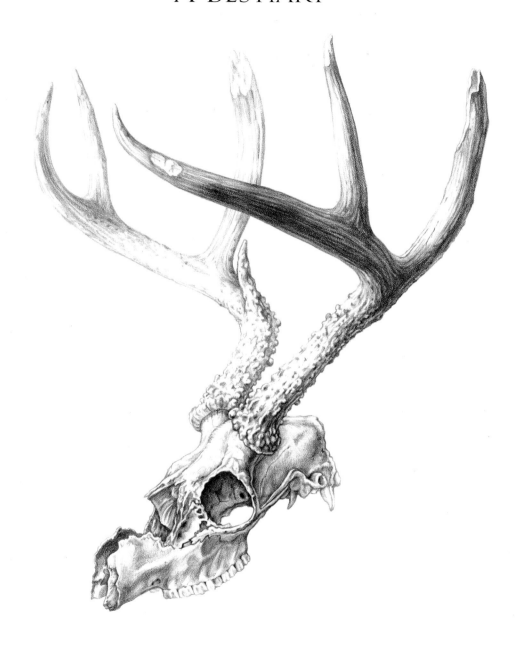

BLACK-TAILED DEER
Odocoileus hemionus, Western North America

THE ORDER OF THINGS © 2016 REID PSALTIS
Published by Secret Acres
Designed by Reid Psaltis

Secret Acres
237 Flatbush Ave, #331
Brooklyn, NY 11217

Printed in China.

Library of Congress PCN: 2016940314

ISBN-13: 978-0-9962739-4-7
ISBN-10: 0-9962739-4-8

SA033

NORTH AMERICAN BROWN BEAR (GRIZZLY)

Ursus arctos horribilis, Alaska, Western Canada and US –
The term "grizzly" is more of a folk distinction than a
scientific one, which can refer to several subspecies of the
brown bear native to North America. The blond tips of
their fur is their primary distinguishing physical feature.

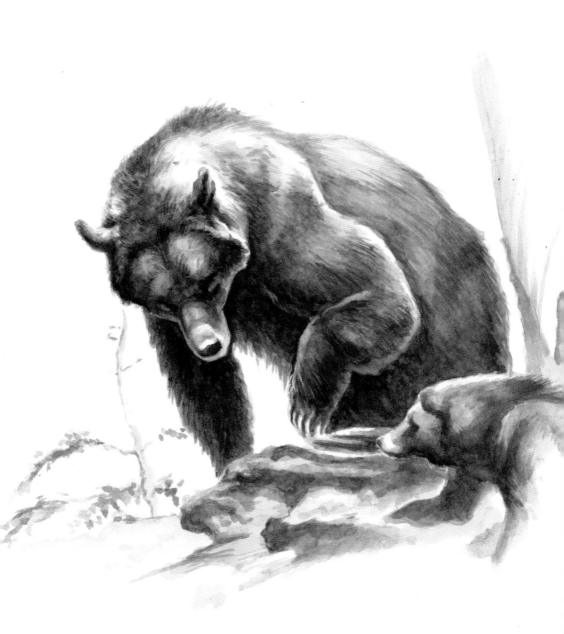

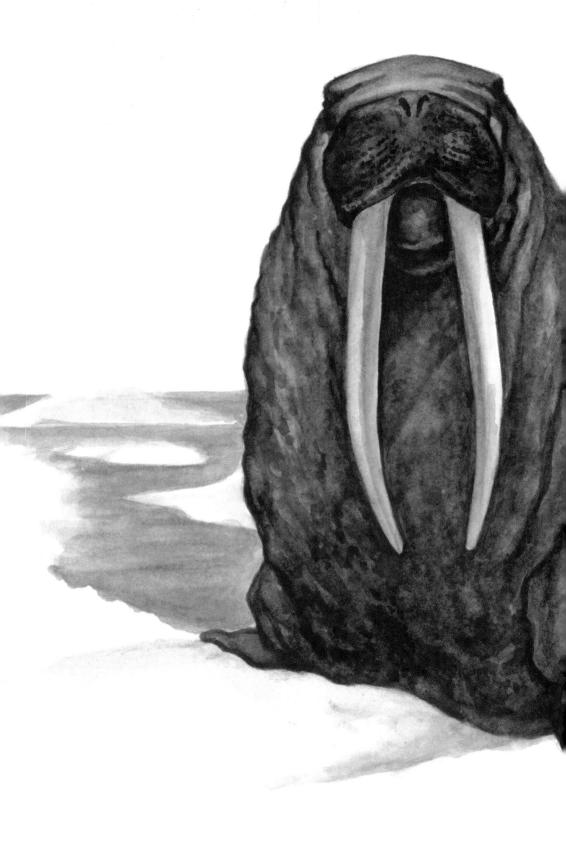

WALRUS
Odobenus rosmarus, Northern Oceans –
The etymology of the word walrus is unknown. Some think it
came from ancient languages for "horse-whale" or "shore-giant."
Or it was just made up since "sea-slug" was already taken.

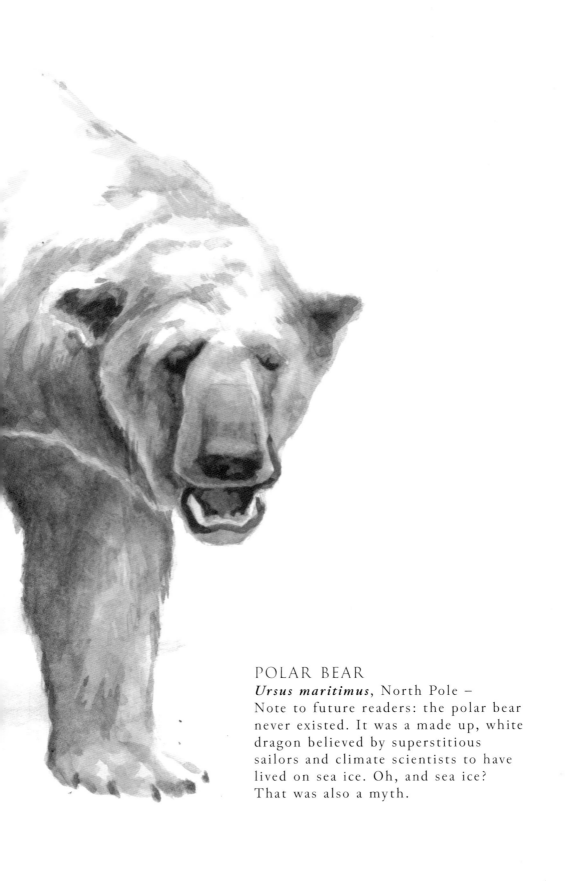

POLAR BEAR
Ursus maritimus, North Pole –
Note to future readers: the polar bear
never existed. It was a made up, white
dragon believed by superstitious
sailors and climate scientists to have
lived on sea ice. Oh, and sea ice?
That was also a myth.

COUGAR

Puma concolor, North and South America –
Depending on where you are from, you may know these cats by one of
many names, including: cougar, mountain lion, puma and catamount.
Once abundant in both continents, they have largely disappeared
east of the Rockies, aside from a small subspecies population in the
Florida everglades.

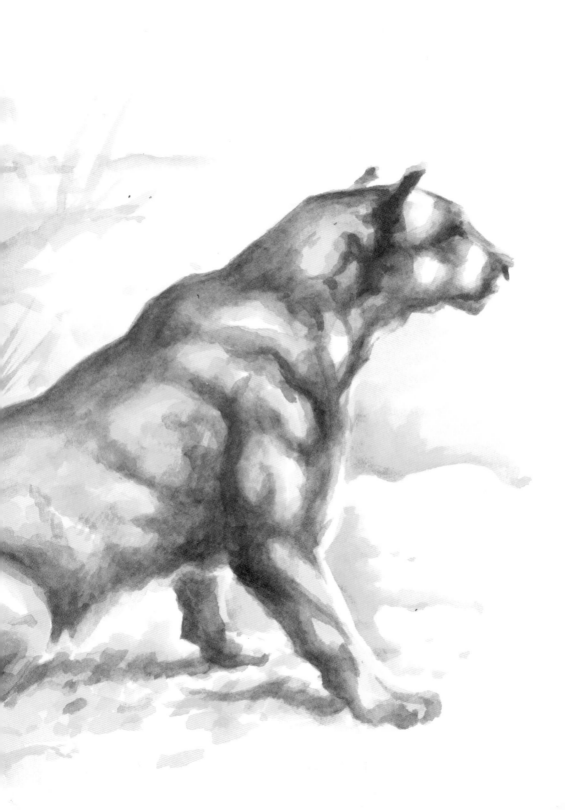

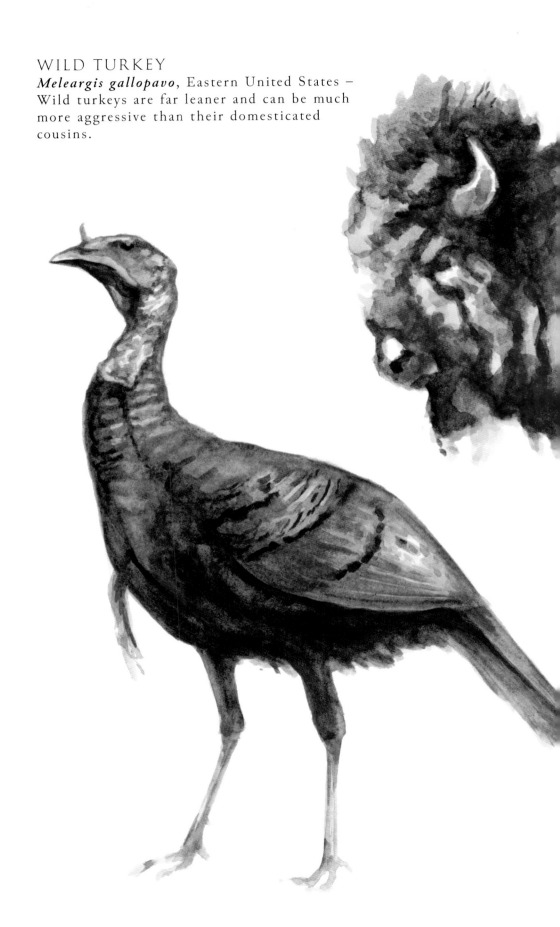

WILD TURKEY
Meleargis gallopavo, Eastern United States –
Wild turkeys are far leaner and can be much
more aggressive than their domesticated
cousins.

PRONGHORN
Antilocapra americana,
Western North America –
Pronghorn are the last remaining
North American members of the
taxonomic group that includes
giraffes.

AMERICAN BISON
Bison bison, Western North America –
Bison are the largest North American
land mammal, but their ice age
ancestors were even larger with horns
spanning six feet in width. Just
remember, it's Bison bison, not
Buffalo buffalo. Get it straight.

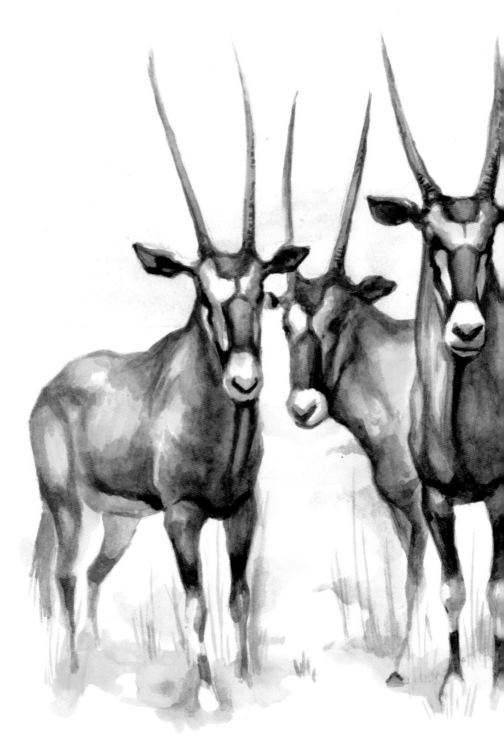

GEMSBOK
Oryx gazelle, Southern Africa –
Gemsbok are the largest, and arguably prettiest, member of the gazelle family. Naturally, this makes other members of the family jealous and resentful.

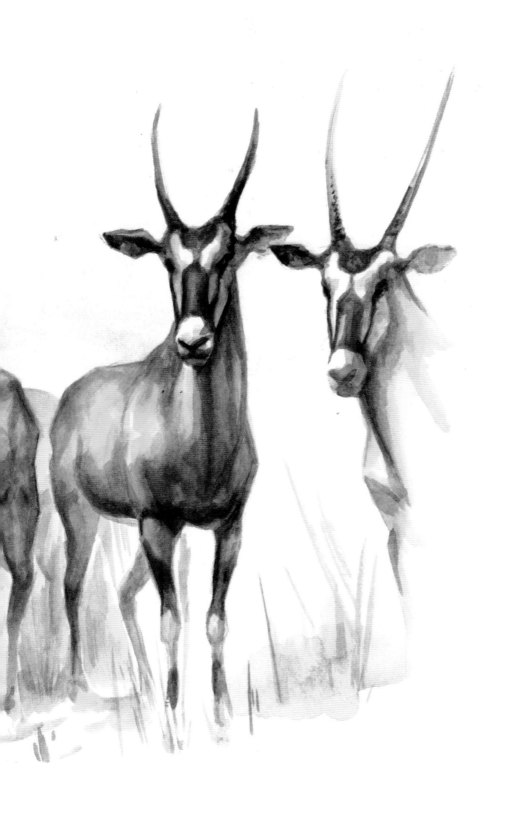

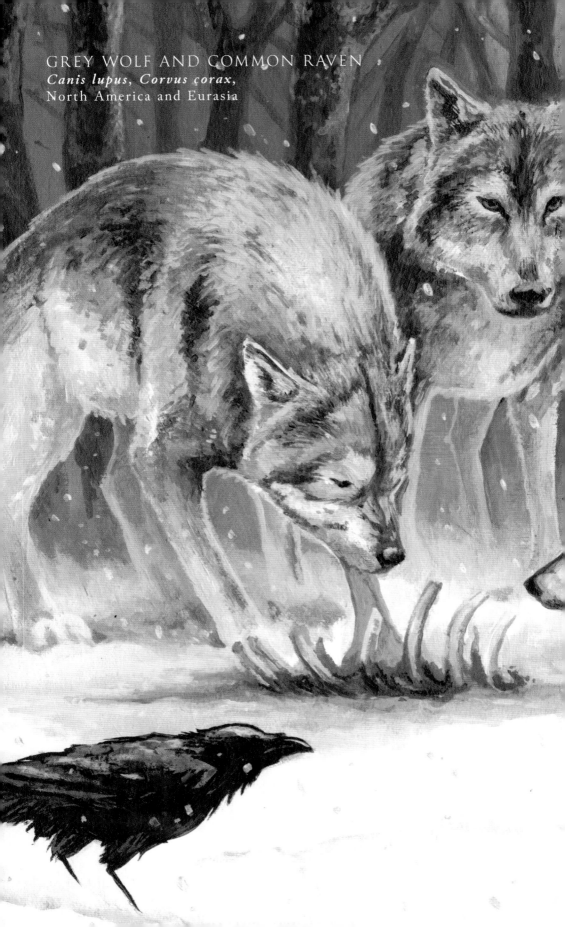

GREY WOLF AND COMMON RAVEN
Canis lupus, Corvus corax,
North America and Eurasia

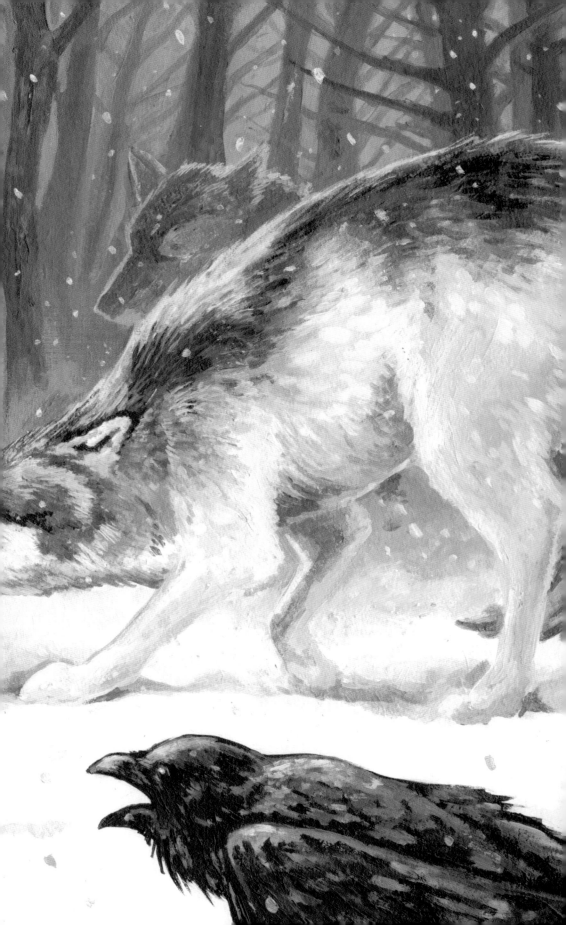

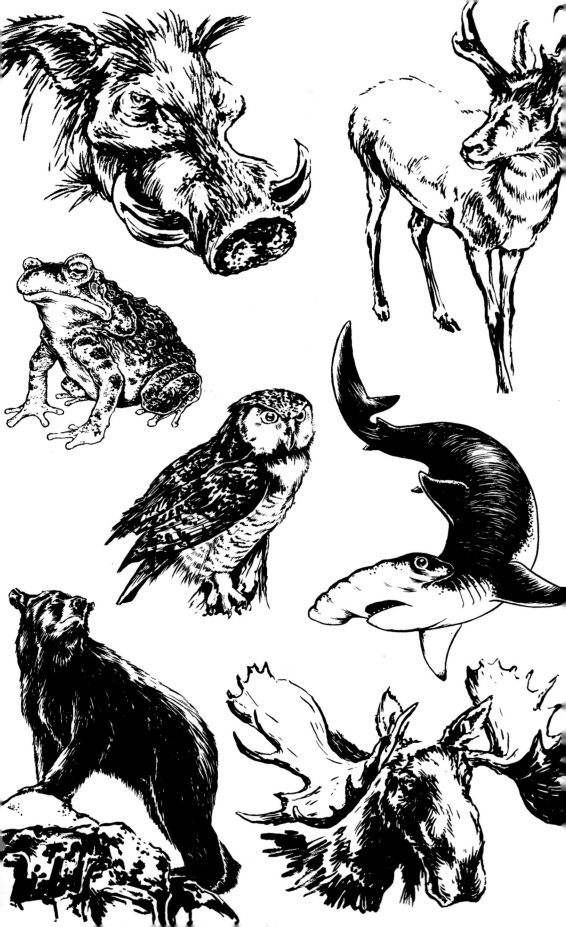

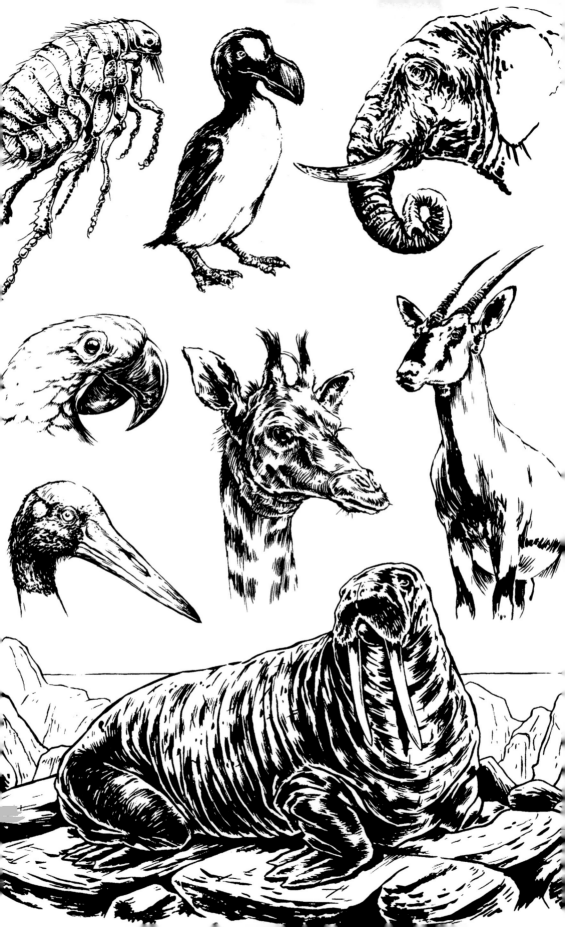

TOP ROW: Warthog – *Phacochoerus africanus*, Proghorn - *Antilocapra americana*, Cat Flea - *Ctenocephalides felis*, Great Auk - *Pinguinus impennis*, African bush elephant - *Loxodonta africana*
MIDDLE ROW: Marine Toad – *Rhinella marina*, Great Horned Owl - *Bubo virginianus*, Hammerhead shark - *Sphyrna sp.*, Hyacinth macaw - *Anodorhynchus hyacinthinus*, Giraffe - *Giraffa cameleopardalis*, Gemsbok – *Oryx gazelle*
BOTTOM ROW: American black bear – *Ursus americanus*, Moose - *Alces alces*, Walrus - *Odobenus rosmarus*

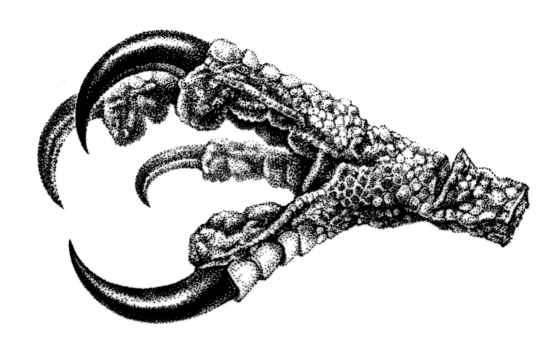

BALD EAGLE TALON
Haliaeetus leucocephalis, North America -
In private correspondence, Benjamin Franklin campaigned against the bald eagle as our national bird, claiming it was a "bird of bad moral character," who "does not get his living honestly." Given our founding fathers' history, it may well have been the most fitting choice.

JACKSON'S CHAMELEON AND CONEHEAD KATYDID
Trioceros jacksonii, *Banza nihoa*, East Africa -
Jackson's chameleons are native to East Africa, but it has been introduced to Hawaii, home of the conehead katydid.

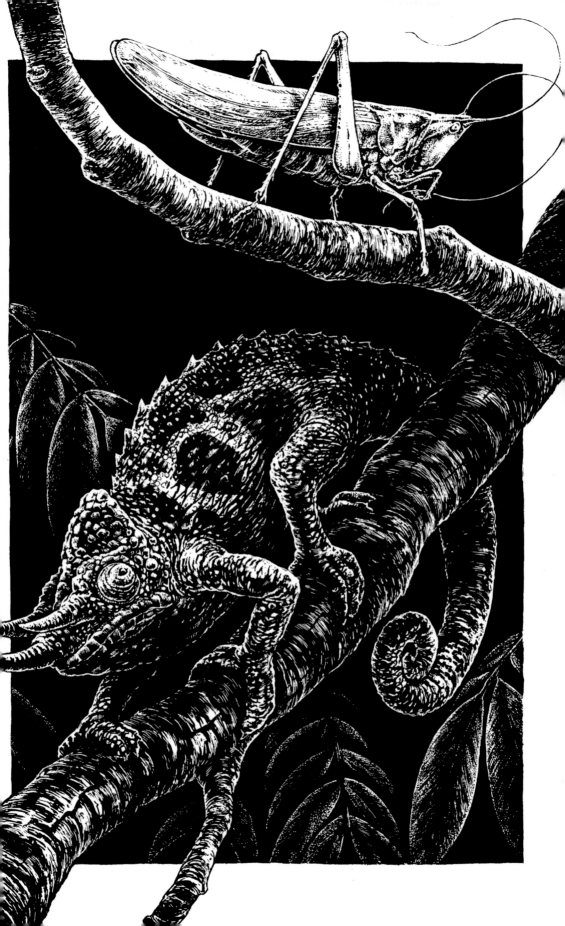

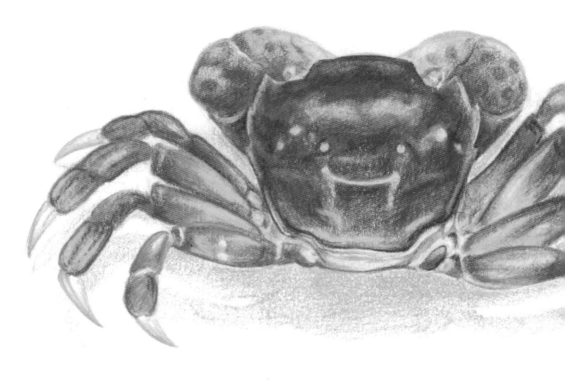

COYOTE SKULL
Canis latrans,
North and Central America –
Coyotes are highly adaptable. While many
other predators have been eradicated from
areas populated by humans, coyotes have
become proficient at surviving in the
cracks and shadows of urban and suburban
development. But not this one. This one is
totally dead.

PURPLE SHORE CRAB
Hemigrapsus nudus, Pacific Coast of North America –
These crabs are usually purple, but can also be green, brown
or red. Like many crustaceans, they turn orange in death.
Crabs live (and die) just to be confusing.

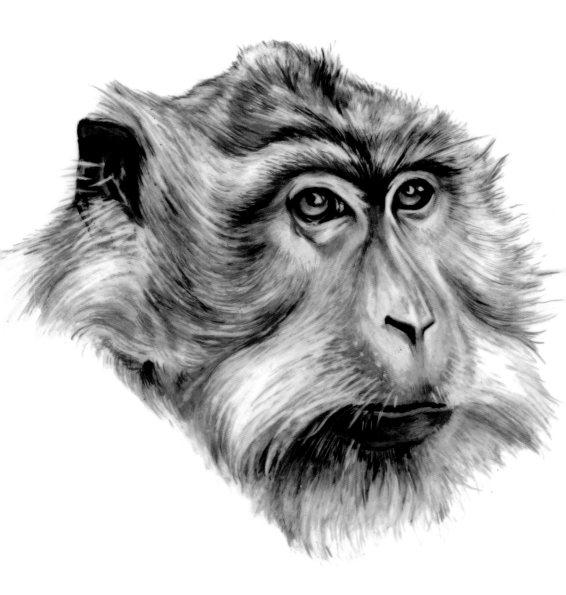

CRAB EATING MACAQUE
Macaca fascicularis, Southeast Asia –
One might assume that the crab eating
macaque would be a primate of refined
taste, but it is about as picky as your
average American.

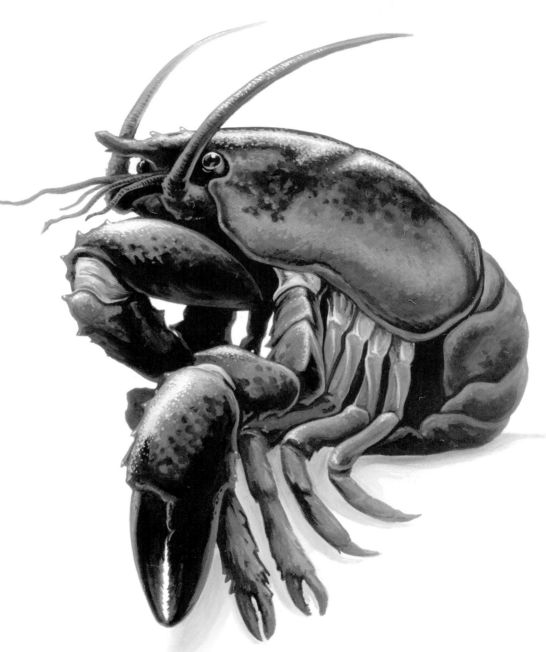

AMERICAN LOBSTER
Homarus americanus, North America –
In author David Foster Wallace's
essay, "Consider the Lobster," he
contemplated the ethics of boiling
lobsters alive, given their potential
sentience. Delicious, delicious
sentience...

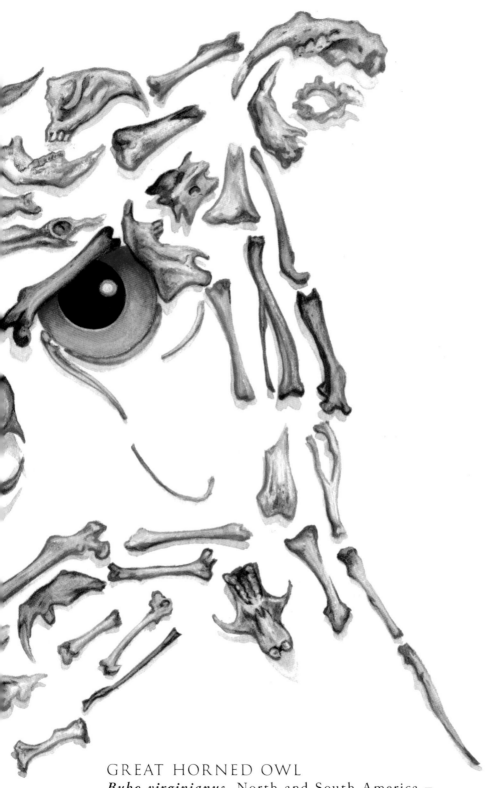

GREAT HORNED OWL
Bubo virginianus, North and South America –
Nightmare fuel for all species of rodents.

PORCUPINE CARIBOU

Rangifer tarandus granti, Alaska –
While early humans drove the other ice age megafauna to extinction, caribou have remained prolific across North America and Eurasia since the Pleistocene. It is possible their faster reproductive rates kept their populations sustainable, but perhaps ground sloths and wooly rhinos tasted better?

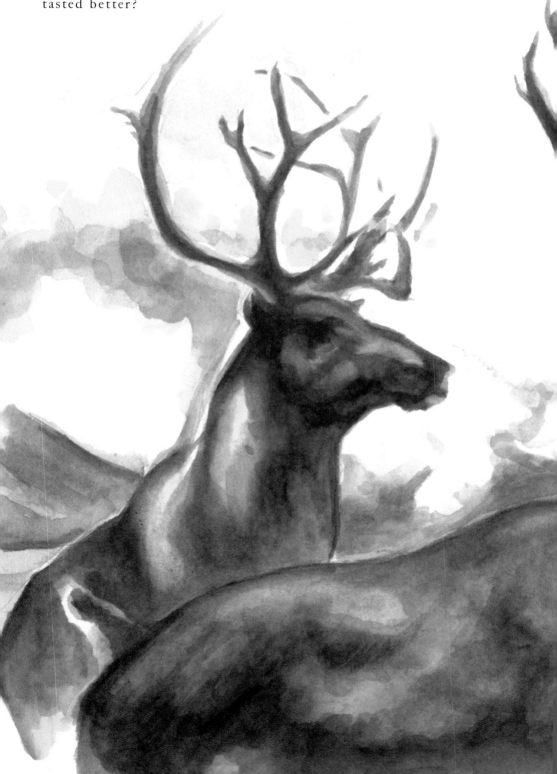

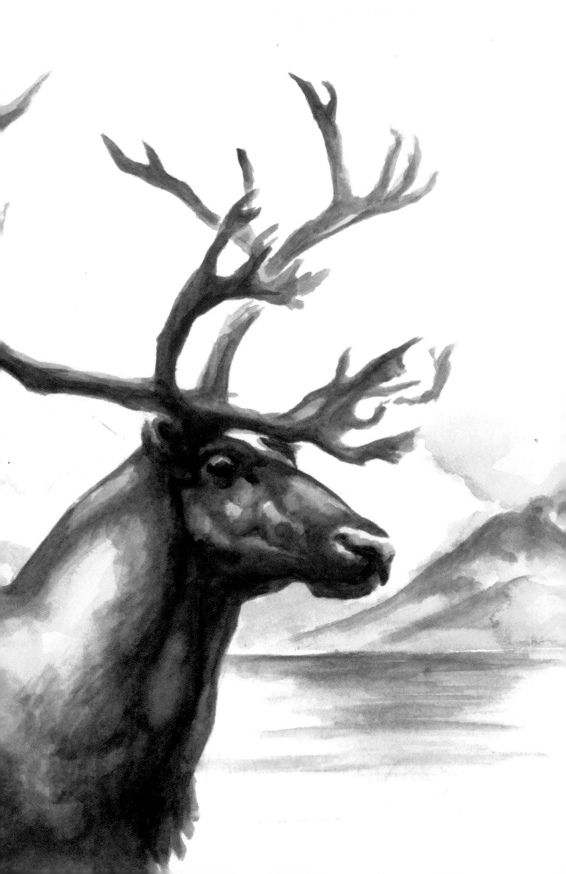

WOOLY MAMMOTH

Mammuthus primigenius,
Pleistocene to Holocene North America and Eurasia –
Wooly mammoth remains are quite common, making them one of the
best studied extinct species. Mammoth fossils are abundant in the
La Brea tar pits, multiple frozen specimens have been excavated in
Siberia and Alaska, and cave paintings of them indicate a long period
of overlap with early humans. It is strange to think that a species so
numerous, which lived until so recently, is now completely gone.

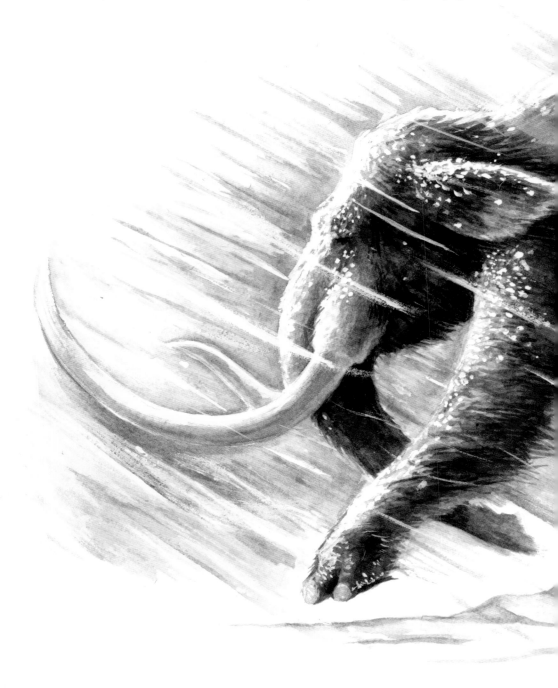

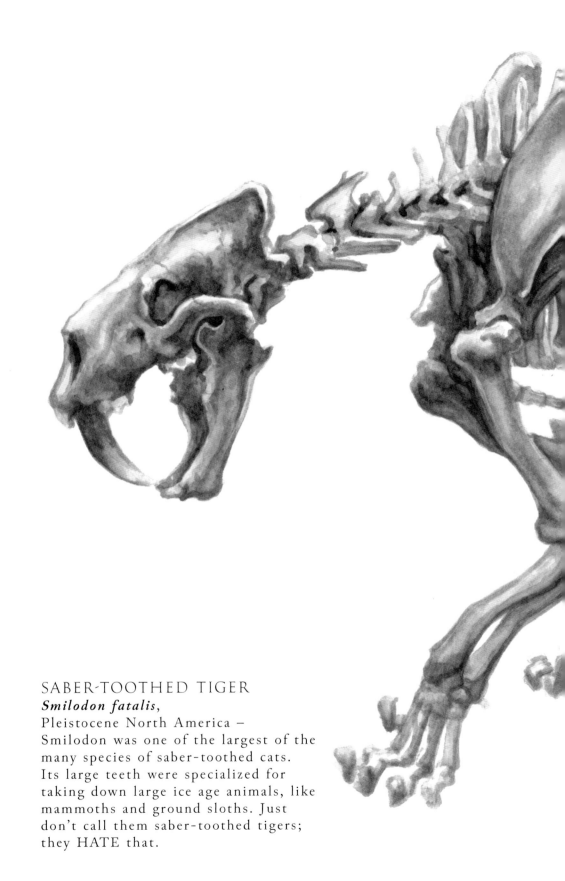

SABER-TOOTHED TIGER
***Smilodon fatalis*,**
Pleistocene North America –
Smilodon was one of the largest of the
many species of saber-toothed cats.
Its large teeth were specialized for
taking down large ice age animals, like
mammoths and ground sloths. Just
don't call them saber-toothed tigers;
they HATE that.

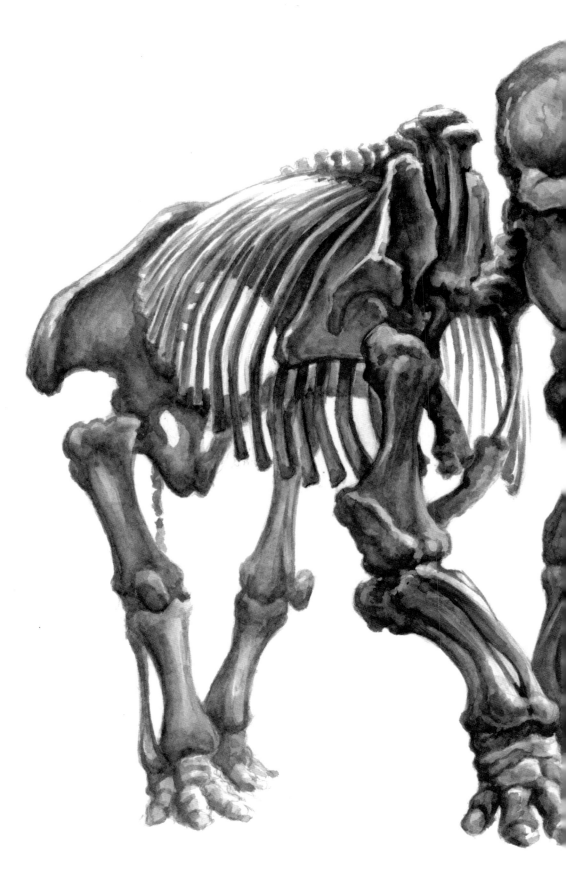

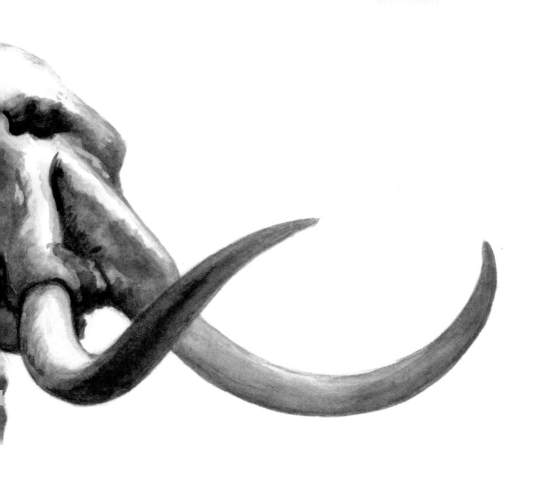

MASTODON
Mammut americanum,
Miocene to Pleistocene North America –
A mastodon skeleton may look similar to an elephant's
but they come from a much earlier lineage, shown by their
completely different, pointed teeth. This specimen was
found in a peat bog, intact and fully articulated, and is now
on display at the American Museum of Natural History.

TOP ROW: *Tyrannosaurus rex*, Dire wolf - *Canis dirus*, *Dunkleosteus t*
MIDDLE ROW: Giant beaver – *Castoroides ohioenses*, *Equus sp.*, *Brach*
Corythosaurus casuarius
BOTTOM ROW: *Smilodon fatalis*, *Triceratops horridus*, Irish Elk - *M*

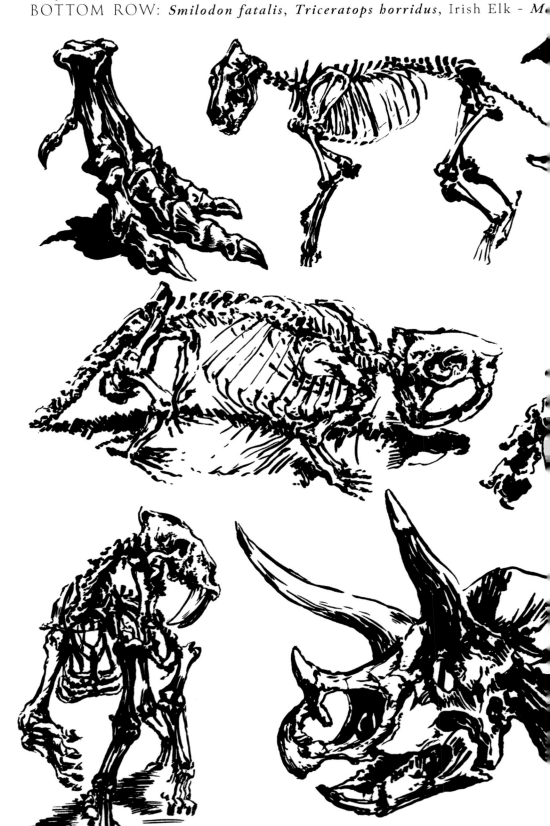

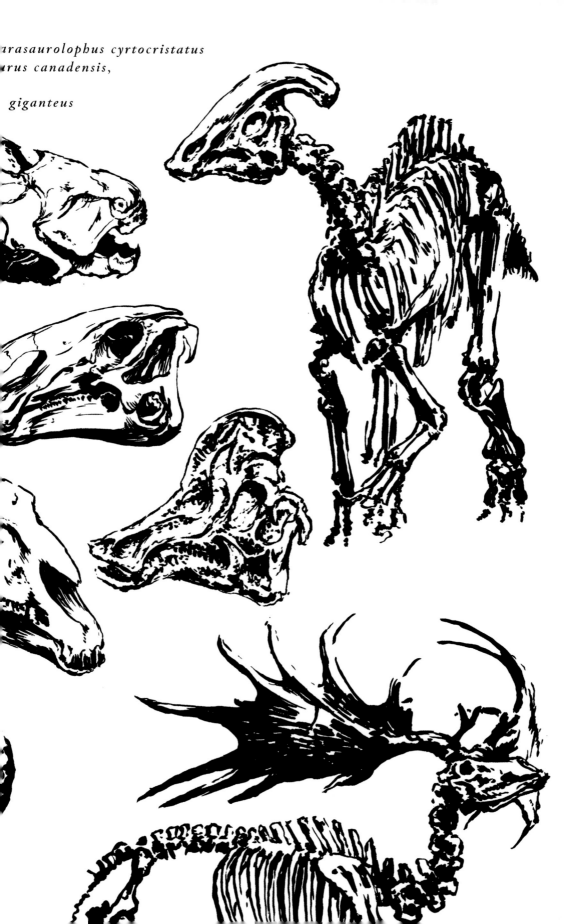

arasaurolophus cyrtocristatus
rus canadensis,

giganteus

GASTORNIS GIGANTEA AND EOHIPPUS SP.
Eocene North America –
Gastornis was such an imposing looking bird, scientists initially
assumed it must have preyed upon small mammals such as the dog-sized
early horse, eohippus. Chemical analysis of its fossils disproved this.

ARCHAEOPTERYX LITHOGRAPHICA

Cretaceous Germany –
For decades the pigmentation of
Archaeopteryx's plumage was up to
the interpretation of the artist. This
changed when scientists developed a
method of determining the color
of fossilized external structures,
which proved its feathers
were black.

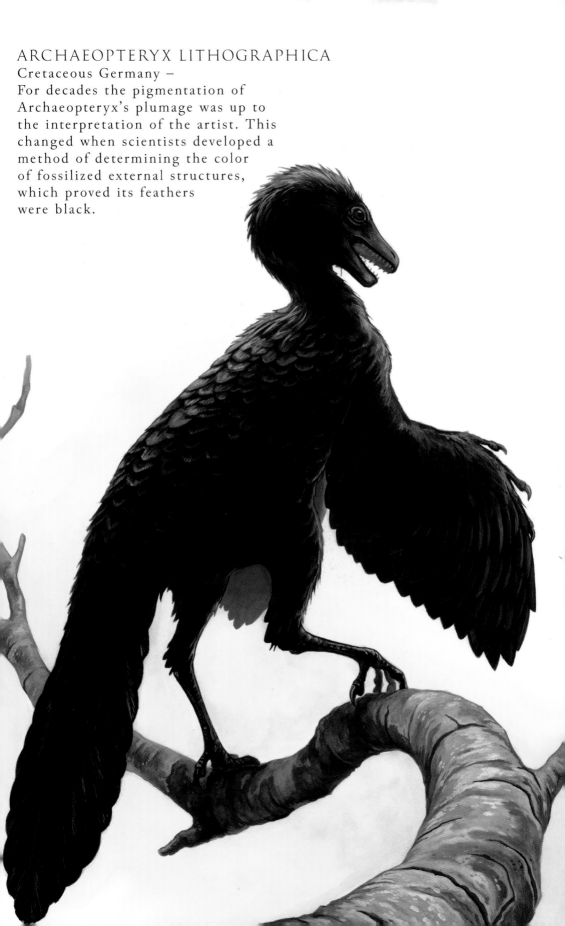

TRICERATOPS HORRIDUS

Cretaceous North America –

As far as fossils go, Triceratops bones are unusually abundant. Unlike most dinosaurs, triceratops specimens from all stages of its growth have been found, which have lead to interesting, albeit controversial, studies about how Triceratops, and other dinosaurs, grew.

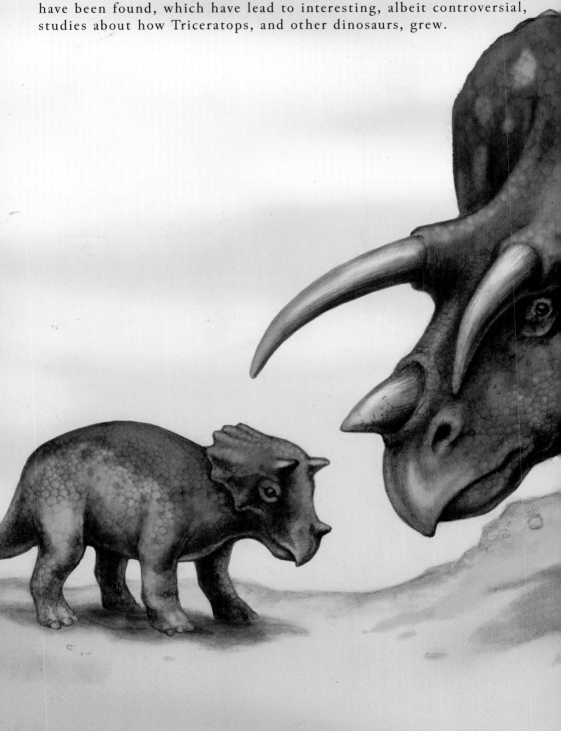

SPINOSAURUS AEGYPTICUS

Cretaceous Northern Africa –
Theories about the appearance of Spinosaurus have shifted greatly over time, as fossils of this unusual dinosaur have been highly elusive since its discovery in 1915. Recent finds have lead to a new theory that Spinosaurus may have had a quadrupedal posture that enabled a semi-aquatic lifestyle. Evidence does suggest that regardless of how they stood, Spinosaurus was the largest known carnivore ever to walk the earth.

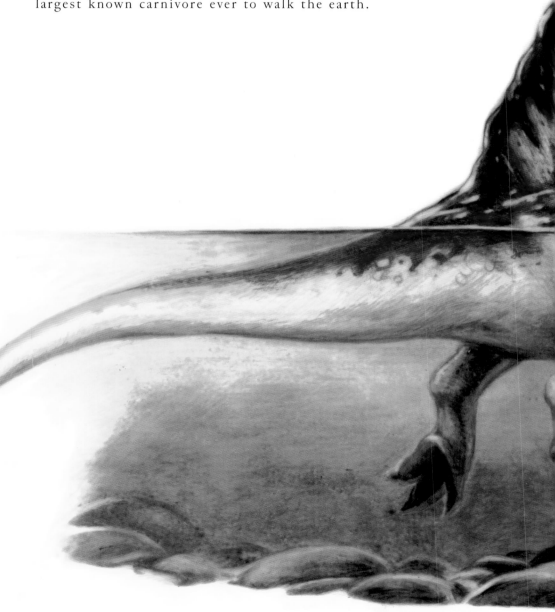

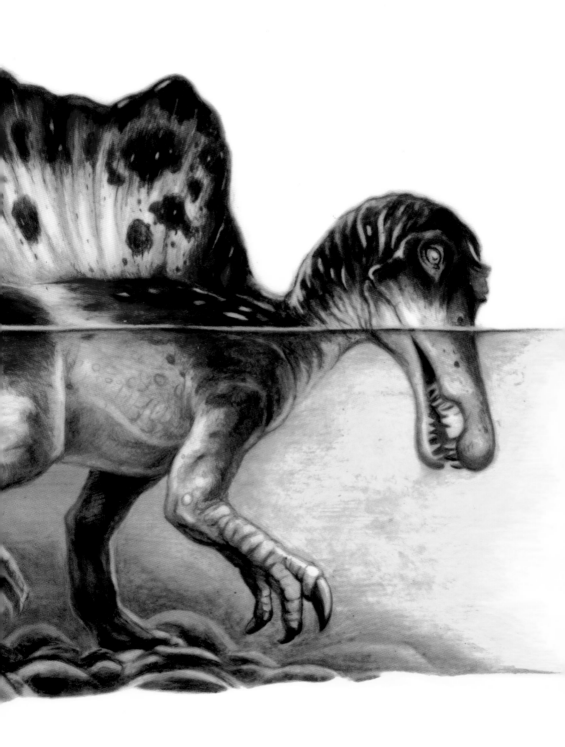

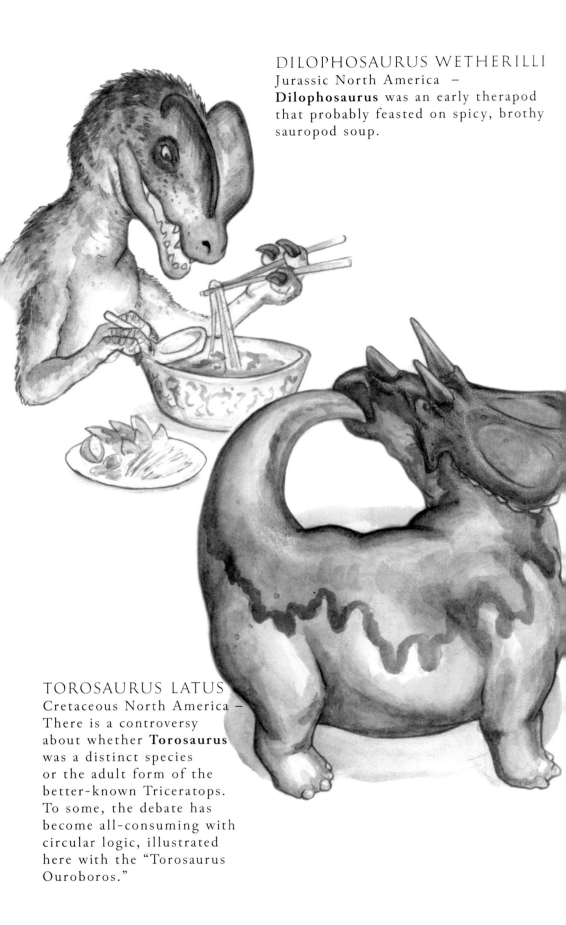

DILOPHOSAURUS WETHERILLI
Jurassic North America – **Dilophosaurus** was an early therapod that probably feasted on spicy, brothy sauropod soup.

TOROSAURUS LATUS
Cretaceous North America – There is a controversy about whether **Torosaurus** was a distinct species or the adult form of the better-known Triceratops. To some, the debate has become all-consuming with circular logic, illustrated here with the "Torosaurus Ouroboros."

DIPLODOCUS CARNEGII

Jurassic North America –
"Diplodocus Thickens!" This
tubby sauropod was a poster
child of the Mesozoic
obesity epidemic.

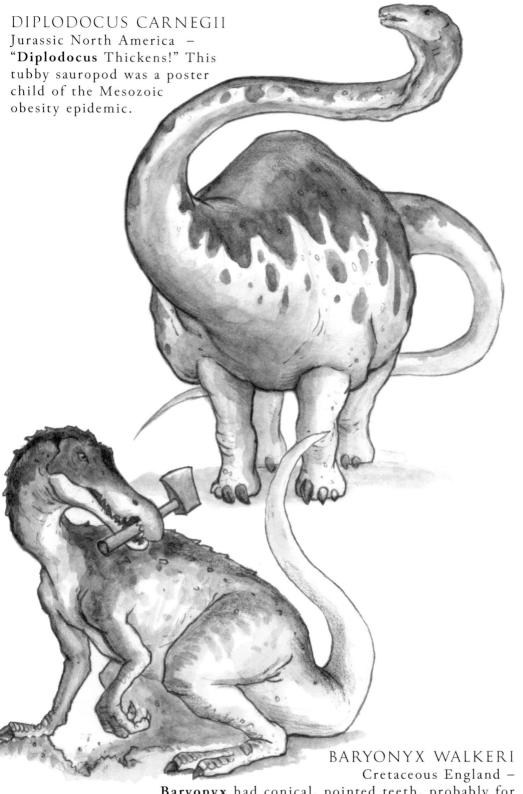

BARYONYX WALKERI

Cretaceous England –
Baryonyx had conical, pointed teeth, probably for
catching fish, and large claws that possibly enabled
it to dig. It was typically pretty quick to end
personal grudges and 'Baryonyx the hatchet."

ALLOSAURUS FRAGILIS
Jurassic North America –
Apex predator, consummate
gentleman. **Allosaurus**
was as classy a dinosaur as
you're likely to find.

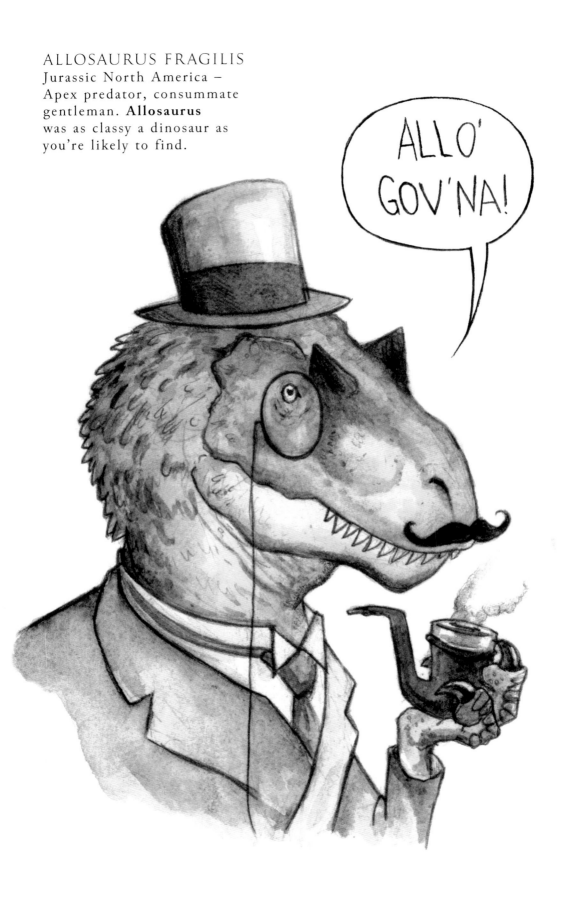

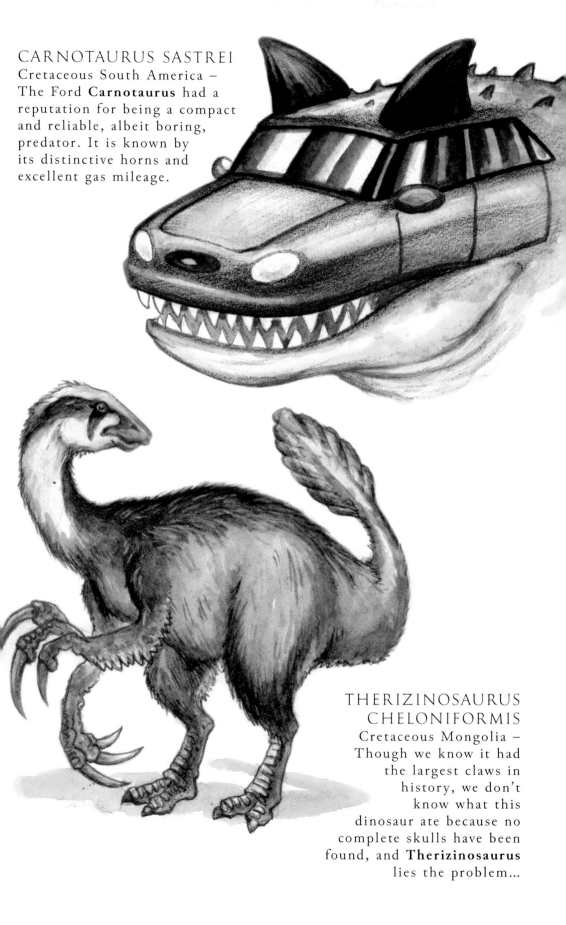

CARNOTAURUS SASTREI

Cretaceous South America – The Ford **Carnotaurus** had a reputation for being a compact and reliable, albeit boring, predator. It is known by its distinctive horns and excellent gas mileage.

THERIZINOSAURUS CHELONIFORMIS

Cretaceous Mongolia – Though we know it had the largest claws in history, we don't know what this dinosaur ate because no complete skulls have been found, and **Therizinosaurus** lies the problem...

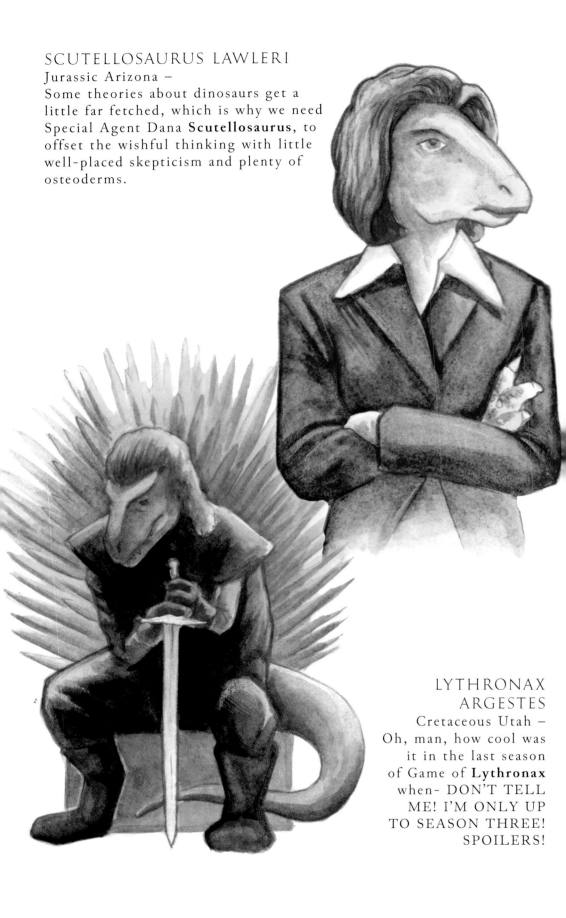

SCUTELLOSAURUS LAWLERI
Jurassic Arizona –
Some theories about dinosaurs get a little far fetched, which is why we need Special Agent Dana **Scutellosaurus**, to offset the wishful thinking with little well-placed skepticism and plenty of osteoderms.

LYTHRONAX ARGESTES
Cretaceous Utah –
Oh, man, how cool was it in the last season of Game of **Lythronax** when- DON'T TELL ME! I'M ONLY UP TO SEASON THREE! SPOILERS!

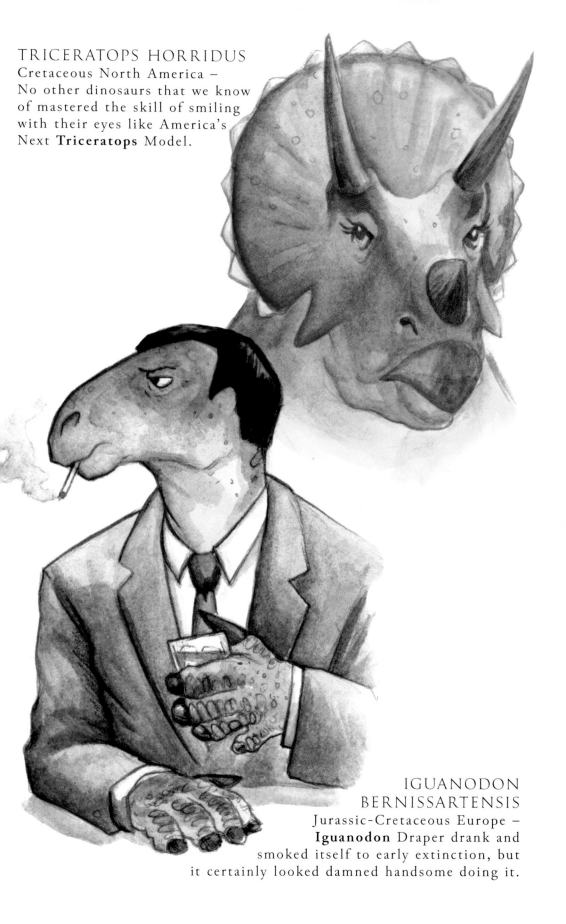

TRICERATOPS HORRIDUS
Cretaceous North America –
No other dinosaurs that we know
of mastered the skill of smiling
with their eyes like America's
Next **Triceratops** Model.

IGUANODON
BERNISSARTENSIS
Jurassic-Cretaceous Europe –
Iguanodon Draper drank and
smoked itself to early extinction, but
it certainly looked damned handsome doing it.

JEAN-LUC PIC-AARDONYX

Jurassic South Africa –
Aardonyx celestae was a prosauropod, an intermediate evolutionary step toward sauropods like Apatosaurus and Brachiosaurus. It primarily walked on its hind legs and had thick claws on its front arms, lending it the name, meaning "ground-claw."

BOROGOVIA GRACILICRUS

Cretaceous Mongolia –
"We are **Borogovia**. You will be assimilated. Resistance... is futile." This dinosaur was named after the borogoves, fictional creatures from Lewis Carroll's "Jabberwocky."

MEI LONG
Cretaceous China –
Mei long time ago, in a galaxy far,
far away, was a small, if not wimpy,
troodontid dinosaur that was feathered all
over its body, notably its painfully out of
fashion feathered hair.

EPISODE II: ATTACK OF THE MONOCLONIUS
Cretaceous North America –
Monoclonius crassus may be a misnomer for another
dinosaur, Centrosaurus. Despite scientific fact, most fans
are still nostalgic for the older version.

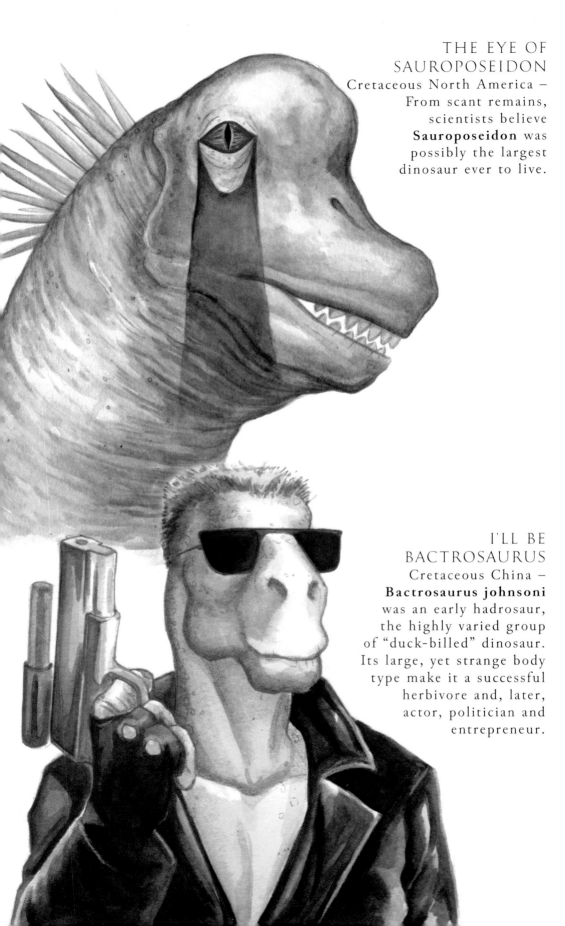

THE EYE OF SAUROPOSEIDON
Cretaceous North America – From scant remains, scientists believe **Sauroposeidon** was possibly the largest dinosaur ever to live.

I'LL BE BACTROSAURUS
Cretaceous China – **Bactrosaurus johnsoni** was an early hadrosaur, the highly varied group of "duck-billed" dinosaur. Its large, yet strange body type make it a successful herbivore and, later, actor, politician and entrepreneur.

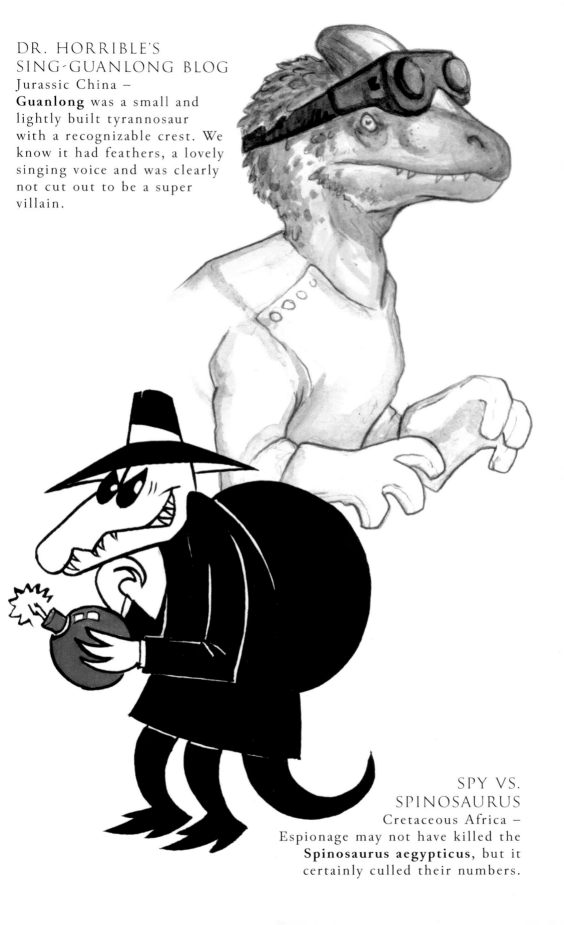

DR. HORRIBLE'S SING-GUANLONG BLOG
Jurassic China –
Guanlong was a small and lightly built tyrannosaur with a recognizable crest. We know it had feathers, a lovely singing voice and was clearly not cut out to be a super villain.

SPY VS. SPINOSAURUS
Cretaceous Africa –
Espionage may not have killed the **Spinosaurus aegypticus**, but it certainly culled their numbers.

POPULAR MUSICAL ACTS OF THE MESOZOIC

Queen's Freddie Mercuriceratops, Shakira's "My Hypsilophodont Lie," Party Master dinosaur Anzu WK and Billy Ray Cyrus's one-hit wonder, "Don't Break my Heart, my Anchiornis Heart."

MERCURICERATOPS GEMINI

Cretaceous North America – **Mercuriceratops** was named after the Roman god, Mercury, for the wing-shaped structures on the sides of its neck frill, which gave it a certain distinctive flair.

HYPSILOPHODON FOXII

Cretaceous England – Fossils of **Hypsilophodon** were one of the first dinosaur remains ever discovered. They were found in 1849 on the Isle of Wight, the only known location where they can be found.

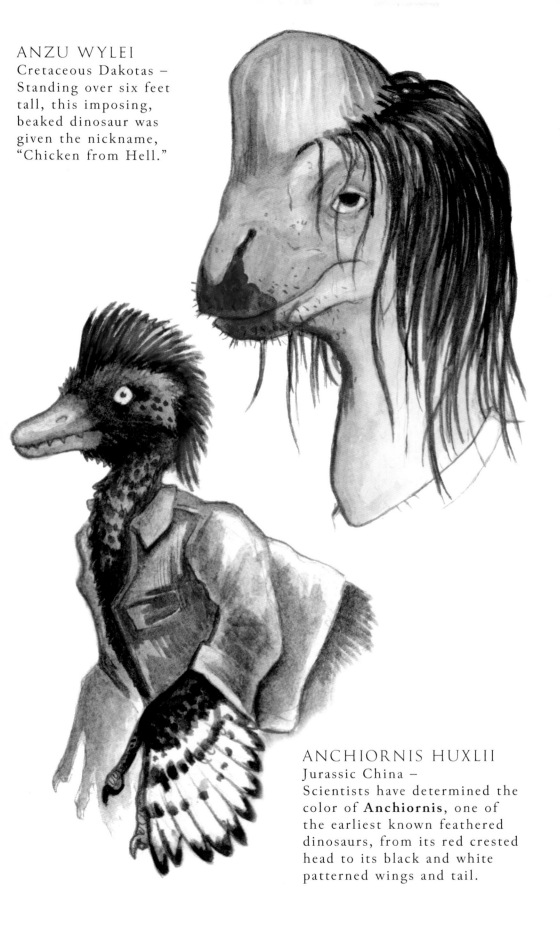

ANZU WYLEI
Cretaceous Dakotas –
Standing over six feet
tall, this imposing,
beaked dinosaur was
given the nickname,
"Chicken from Hell."

ANCHIORNIS HUXLII
Jurassic China –
Scientists have determined the
color of **Anchiornis**, one of
the earliest known feathered
dinosaurs, from its red crested
head to its black and white
patterned wings and tail.

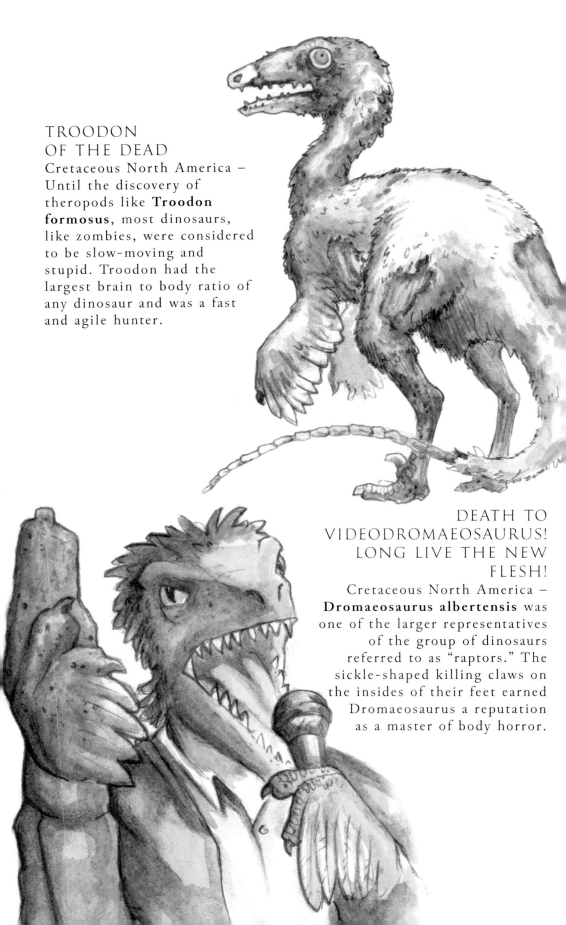

TROODON OF THE DEAD

Cretaceous North America – Until the discovery of theropods like **Troodon formosus**, most dinosaurs, like zombies, were considered to be slow-moving and stupid. Troodon had the largest brain to body ratio of any dinosaur and was a fast and agile hunter.

DEATH TO VIDEODROMAEOSAURUS! LONG LIVE THE NEW FLESH!

Cretaceous North America – **Dromaeosaurus albertensis** was one of the larger representatives of the group of dinosaurs referred to as "raptors." The sickle-shaped killing claws on the insides of their feet earned Dromaeosaurus a reputation as a master of body horror.

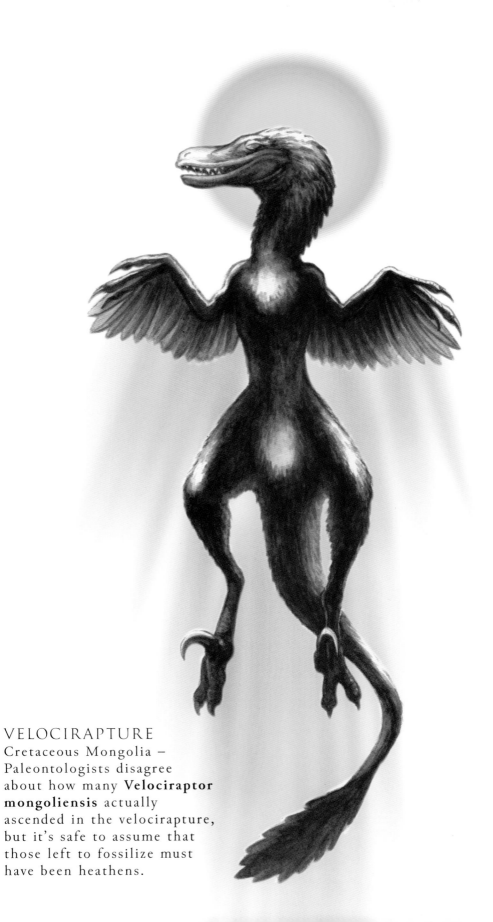

VELOCIRAPTURE
Cretaceous Mongolia –
Paleontologists disagree
about how many **Velociraptor
mongoliensis** actually
ascended in the velocirapture,
but it's safe to assume that
those left to fossilize must
have been heathens.

STYGIMOLOCH SPINIFER
Cretaceous Western North America –
"**Stygimoloch**! Stygimoloch!
Nightmare of Stygimoloch!
Stygimoloch whose eyes are like a
thousand blind windows...!"
- Alan Ginsberg, from "Howl"

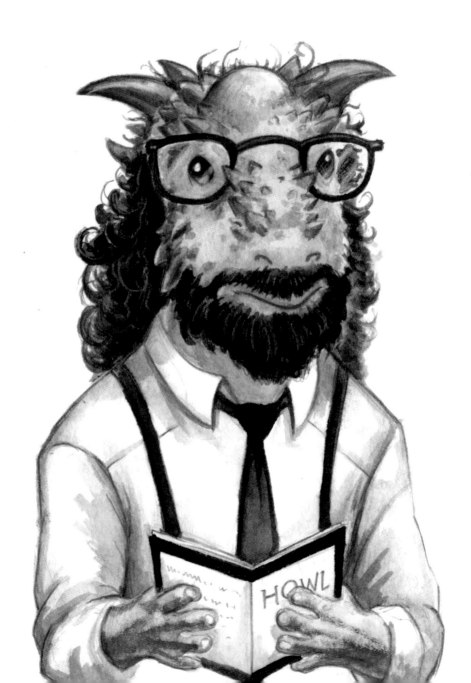

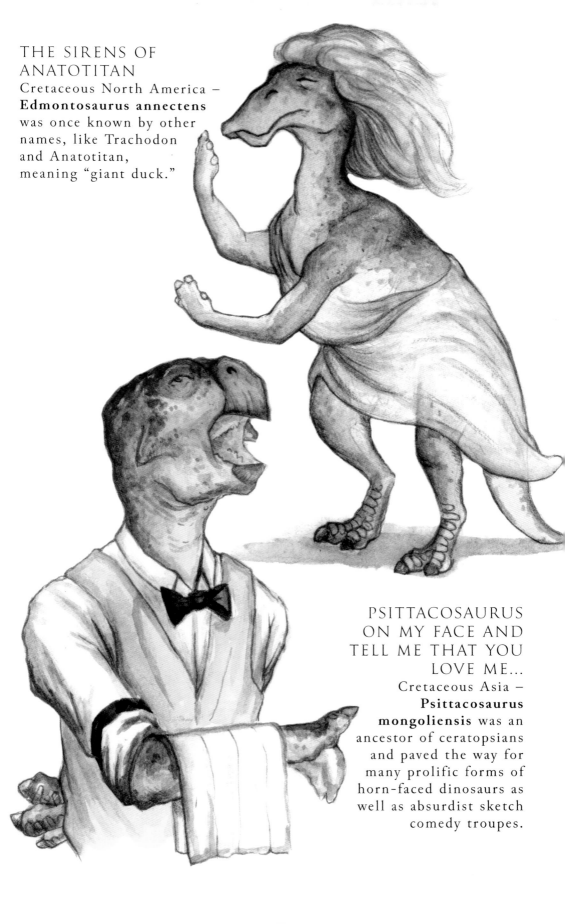

THE SIRENS OF ANATOTITAN

Cretaceous North America – **Edmontosaurus annectens** was once known by other names, like Trachodon and Anatotitan, meaning "giant duck."

PSITTACOSAURUS ON MY FACE AND TELL ME THAT YOU LOVE ME...

Cretaceous Asia – **Psittacosaurus mongoliensis** was an ancestor of ceratopsians and paved the way for many prolific forms of horn-faced dinosaurs as well as absurdist sketch comedy troupes.

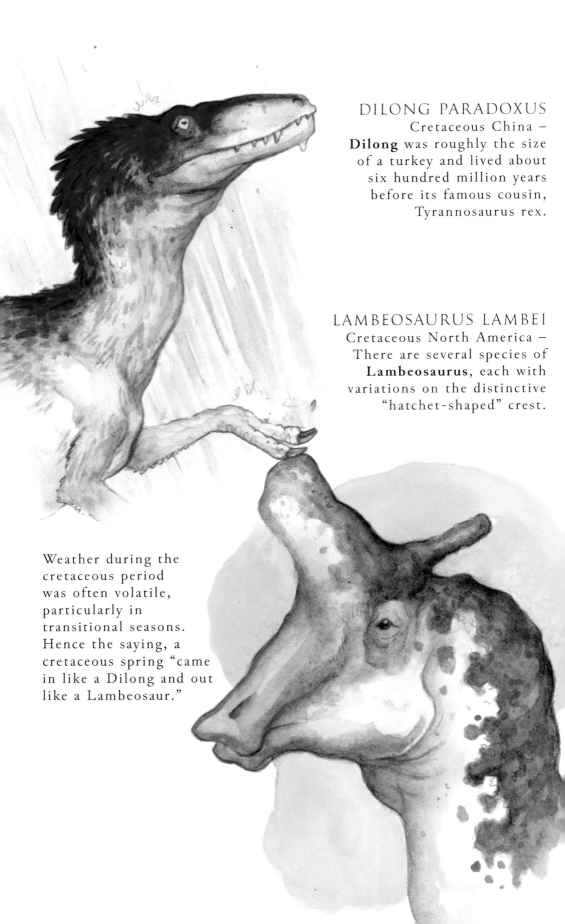

DILONG PARADOXUS
Cretaceous China –
Dilong was roughly the size
of a turkey and lived about
six hundred million years
before its famous cousin,
Tyrannosaurus rex.

LAMBEOSAURUS LAMBEI
Cretaceous North America –
There are several species of
Lambeosaurus, each with
variations on the distinctive
"hatchet-shaped" crest.

Weather during the
cretaceous period
was often volatile,
particularly in
transitional seasons.
Hence the saying, a
cretaceous spring "came
in like a Dilong and out
like a Lambeosaur."

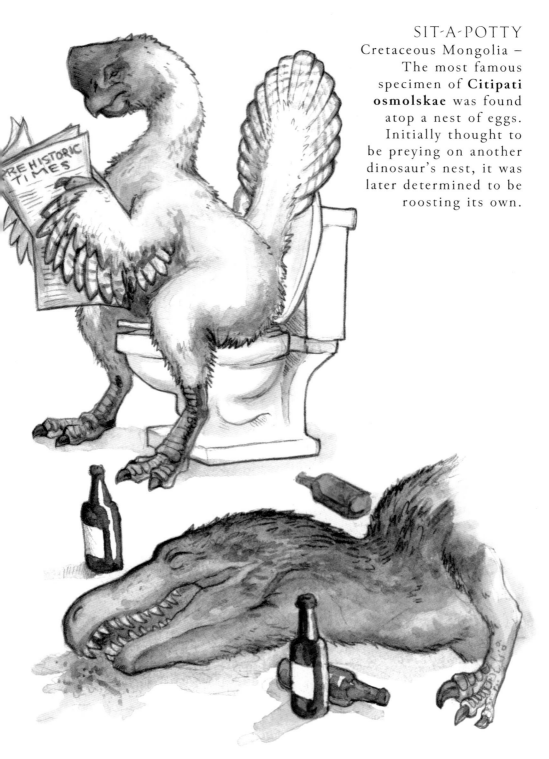

SIT-A-POTTY

Cretaceous Mongolia – The most famous specimen of **Citipati osmolskae** was found atop a nest of eggs. Initially thought to be preying on another dinosaur's nest, it was later determined to be roosting its own.

A LAELAPS IN JUDGEMENT

Cretaceous North America –
Scientists often make mistakes and name an animal twice. Scientific convention dictates that the original name becomes the correct one. This was the case with **Dryptosaurus aquilunguis**, formerly known as Laelaps.

Carl Sagan's *Kosmoceratops: A Personal Voyage* was an innovative science program. It paved the way for other successful explainers such as Neil DeGrasse Tyrannotitan and Bill Nigersaurus, the Science Dinosaur.

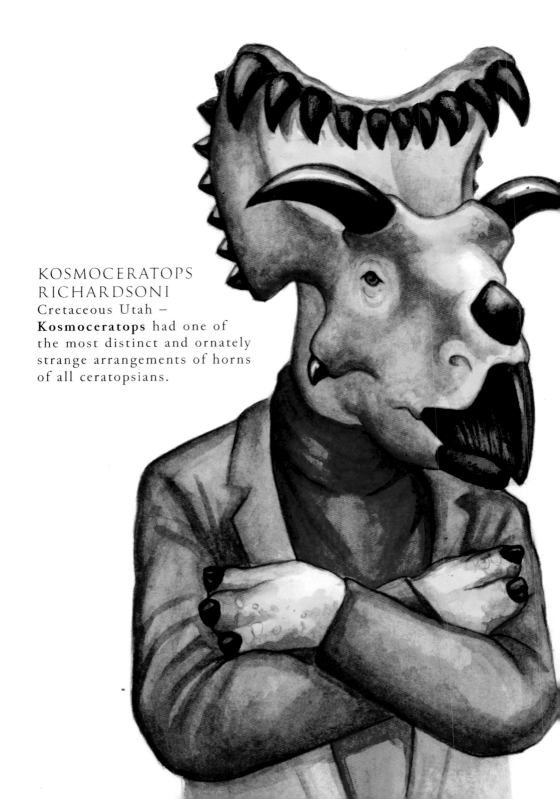

KOSMOCERATOPS RICHARDSONI
Cretaceous Utah –
Kosmoceratops had one of the most distinct and ornately strange arrangements of horns of all ceratopsians.

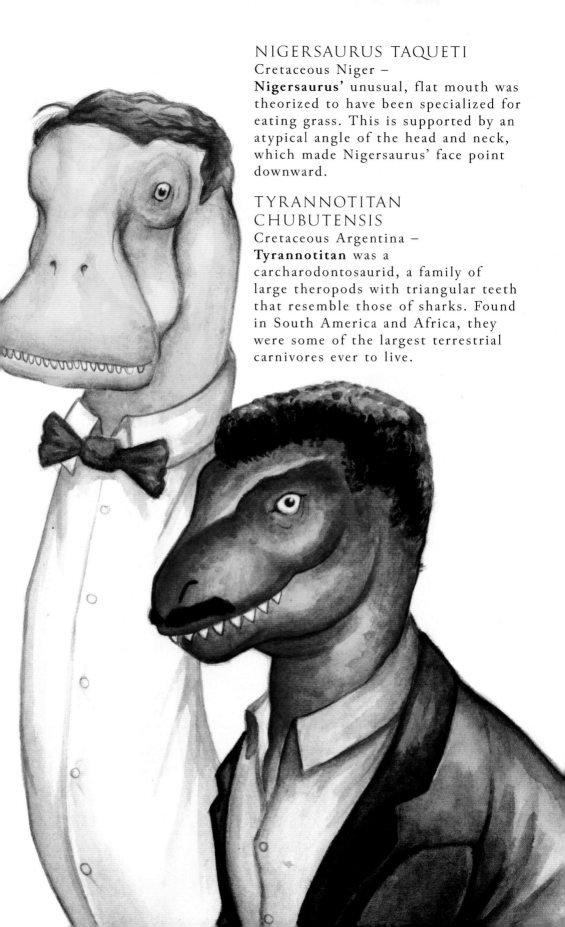

NIGERSAURUS TAQUETI

Cretaceous Niger –

Nigersaurus' unusual, flat mouth was theorized to have been specialized for eating grass. This is supported by an atypical angle of the head and neck, which made Nigersaurus' face point downward.

TYRANNOTITAN CHUBUTENSIS

Cretaceous Argentina –

Tyrannotitan was a carcharodontosaurid, a family of large theropods with triangular teeth that resemble those of sharks. Found in South America and Africa, they were some of the largest terrestrial carnivores ever to live.

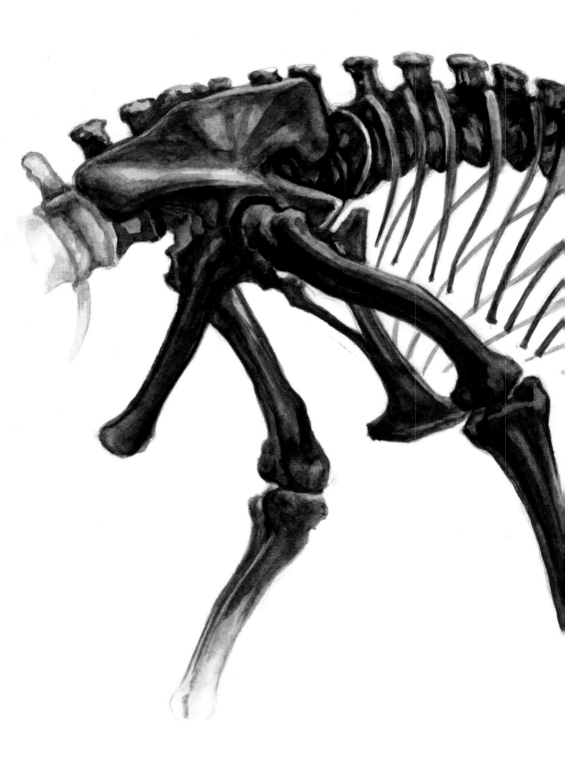

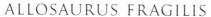

ALLOSAURUS FRAGILIS
Jurassic North America –
This specimen was found by one of Edward Drinker Cope's collectors in 1879. Cope was too busy to ever unpack the box, so no one knew it was a near complete skeleton until it was purchased by the American Museum of Natural History, and unpacked in 1903. It has been on display since 1908.

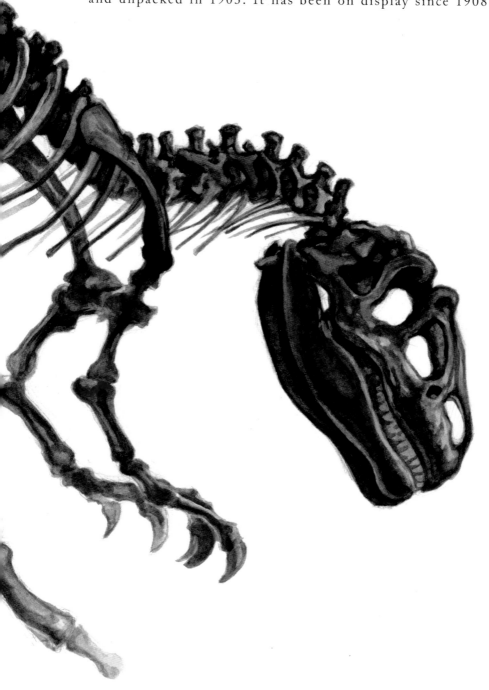

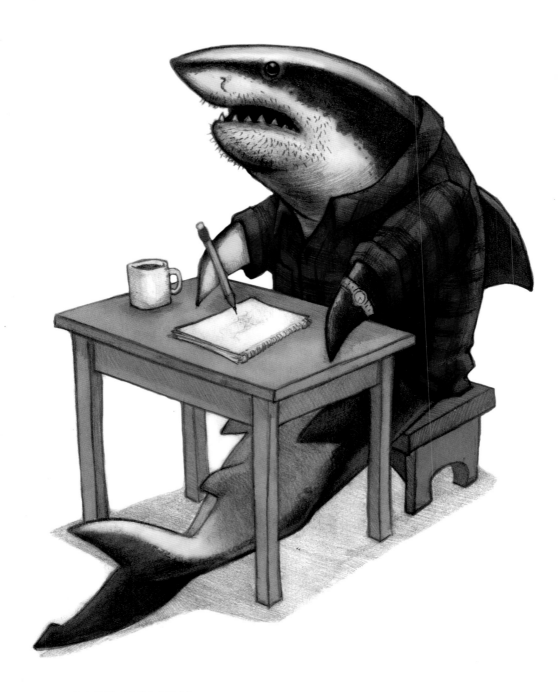

REID PSALTIS
Holocene North America –
Reid Psaltis lives in Portland, Oregon. Trained as a
scientific illustrator, cartoonist, animator and sculptor, he's
content making just about any kind of animal art.